TESTIMONIALS

"Poodles are beautiful intelligent and fiercely loyal companions. The illustrator does a magical job of capturing the whimsical nature of poodles, in their most natural state, as humans! A must for children, adults, and poodle lovers."

– **Jackie Griffin,** owner of Oh My Dog! Boutique Hotel, and poodle lover forever

"Every pet deserves a good life, and the illustrator does an amazing job capturing that belief and showcasing the power of adopting a rescue pet."

– **The Arizona Humane Society**

"Bruno the poodle was a pleasure to work with on the set of the Lexus Commercial at the Trump Tower in Waikiki, Hawaii."

– **Gracie Atkins,** producer, Moana Productions, Inc.

BRUNO THE POODLE'S COLORING BOOK & CREATIVE PAGES

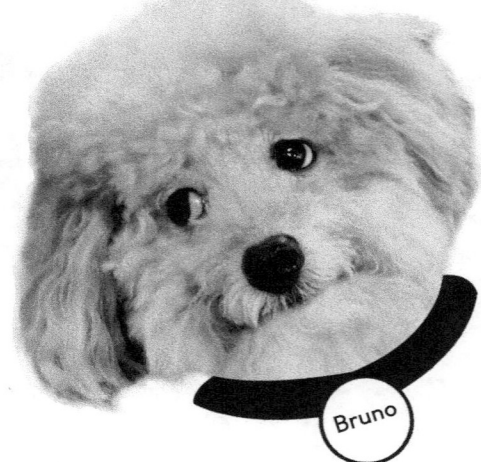

BRUNO THE POODLE'S COLORING BOOK & CREATIVE PAGES

Color, write, draw, and play with Bruno and his friends

J.J. Jordan

Published by J.J. Jordan Press
Scottsdale, AZ
JJPoodles.com

Bruno the Poodle's Coloring Book & Creative Pages

©2019 J.J. Jordan

All rights reserved. The drawings, photos, and creative prompts in this book are the property of the artist/author. They may not be reproduced or copied in any media without permission.

ISBN: 978-1694367020 (paperback)

Library of Congress Number: 2019914958

J.J. Jordan Press
Scottsdale, AZ
jjpoodles@gmail.com
jjpoodles.com

Book Shepherd: Ann Narcisian Videan: ANVidean.com

Graphic design: Grace Quest: TheGraceQuest.com

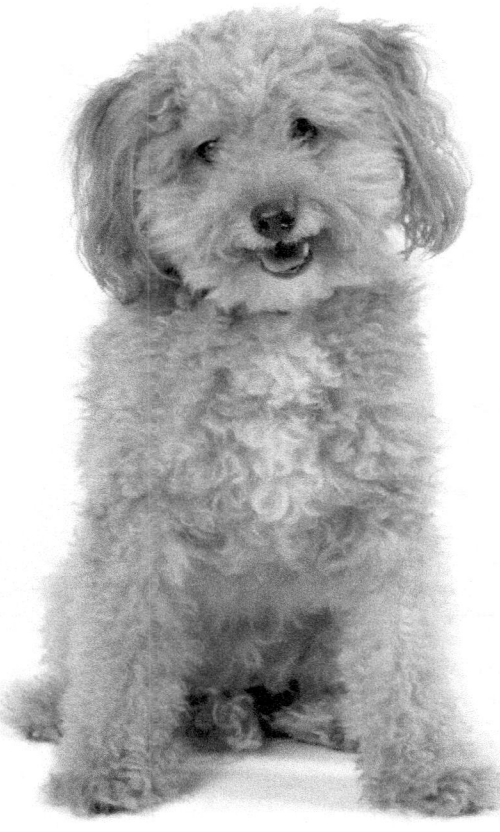

Hello, humans, my name is Bruno, and I am the favorite companion of J.J. Jordan, who authored and illustrated this book. I'd say I'm tickled pink, but that's typically reserved for the females of my illustrious breed.

After sharing so many years at my human companion's side, I'm thrilled she decided to create this fun book in my name. It gives me the opportunity to share some really fun ideas with you, play some games, and smile a bit, as well as showcase some of the excellent places I've visited with J.J., and honor her former "best friends."

You know, I've been to California and Hawaii, where I snapped some pretty spectacular photos, if I do say so myself. I've also been in a commercial or two, and walked the yellow brick road with some amazing friends - though we're saving that story for book two. You might have even seen me around the Arizona scene perched in my special stroller "throne," from where I can experience the world and make loads of friends.

Let me leave you with a pleasant, "Woof," which holds in it the wishes for you to enjoy every creative page and to further develop your fondness for the greatest breed of canine on the planet.

In the name of "poodle power!"

- BRUNO

DEDICATION

For:
My husband Chuck.
My sons James and Will, who own rescue dogs.
My very talented friend, colleague, and Art Center College of Design mentor Julie Toy.
And, of course, to my loyal companion, my poodle Bruno.

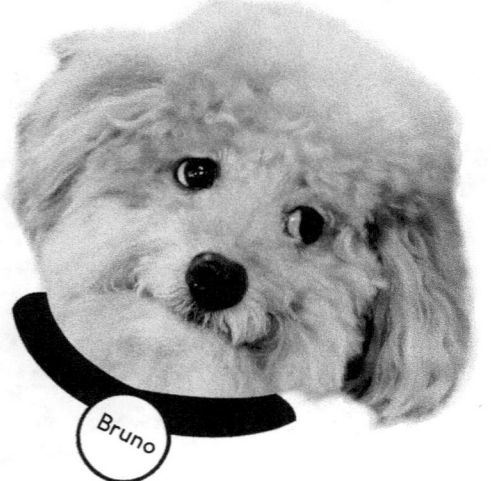

SECTION 1:
SCOTTSDALE, AZ

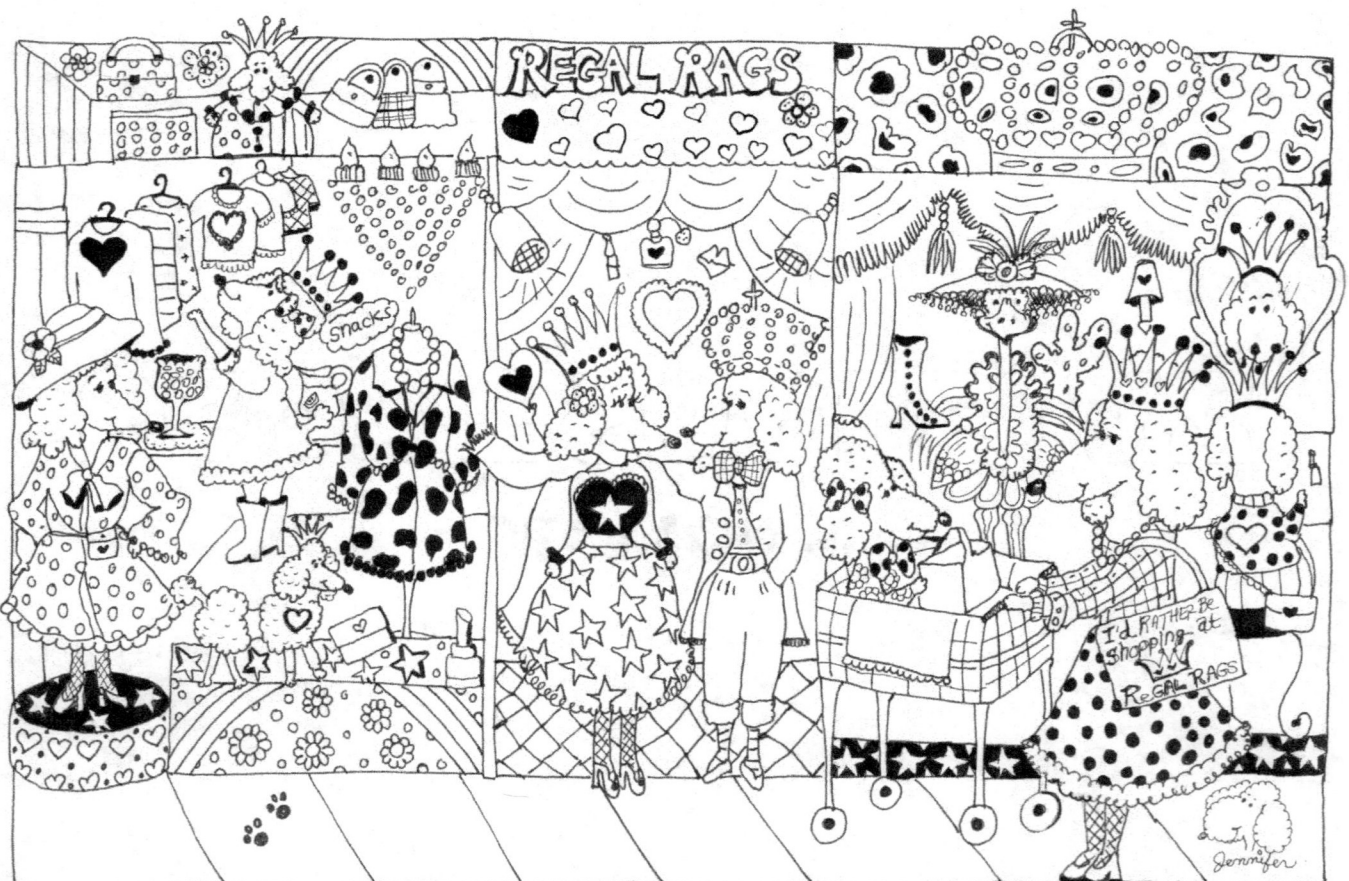

POODLES IN REGAL RAGS

As a fashionista among the poodle set, allow me to ask you to envision your favorite style, wardrobe items, and color scheme. Write or draw it on this page.

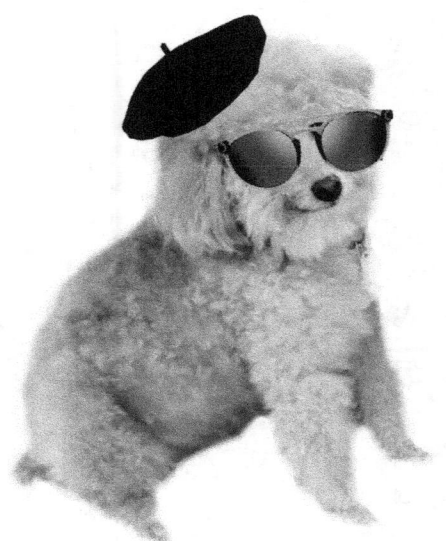

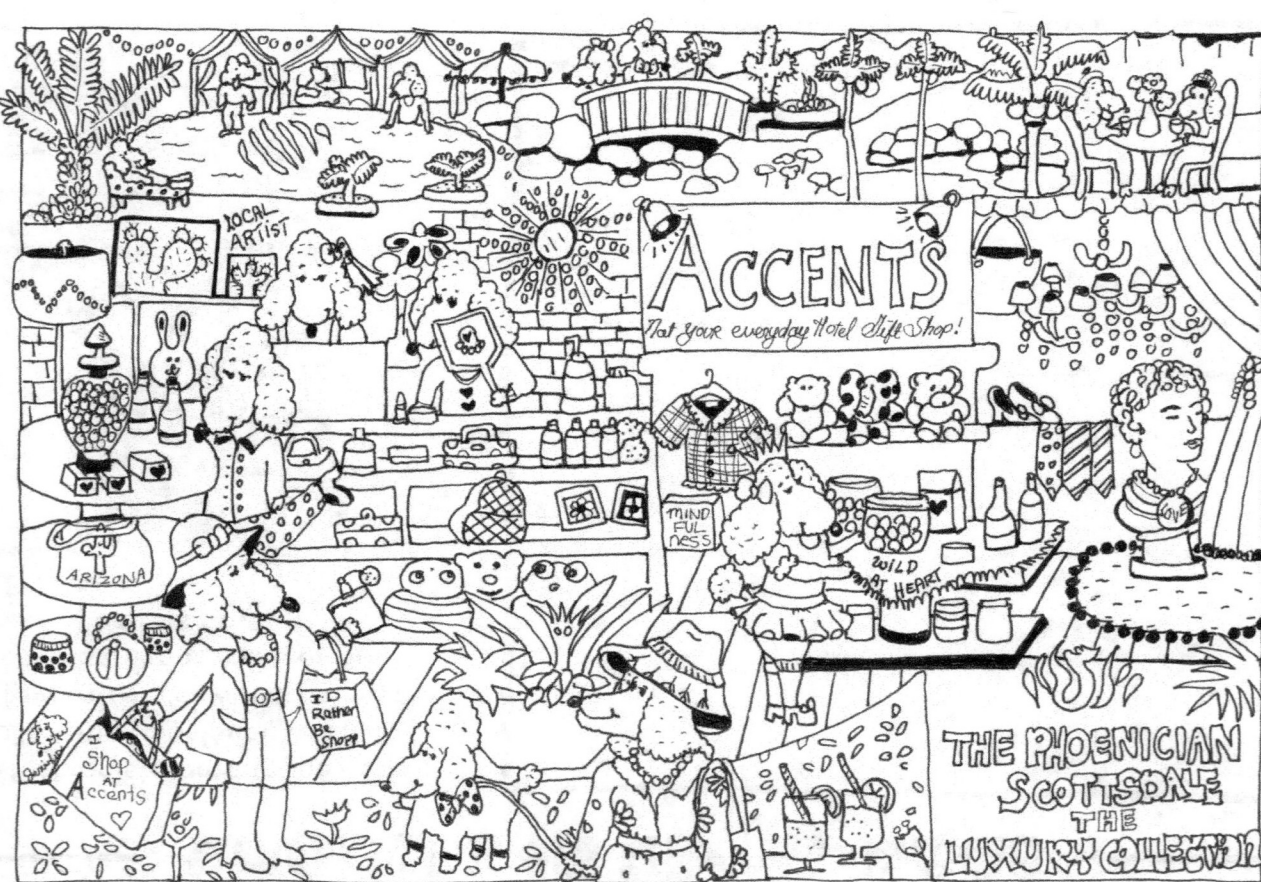

POODLES IN ACCENTS

I love hotels! Share your favorite memories/souvenirs from a destination like The Phoenician's Accents resort shop. Or, share some you want to collect. Snow globes and magnets are a must for Bruno.

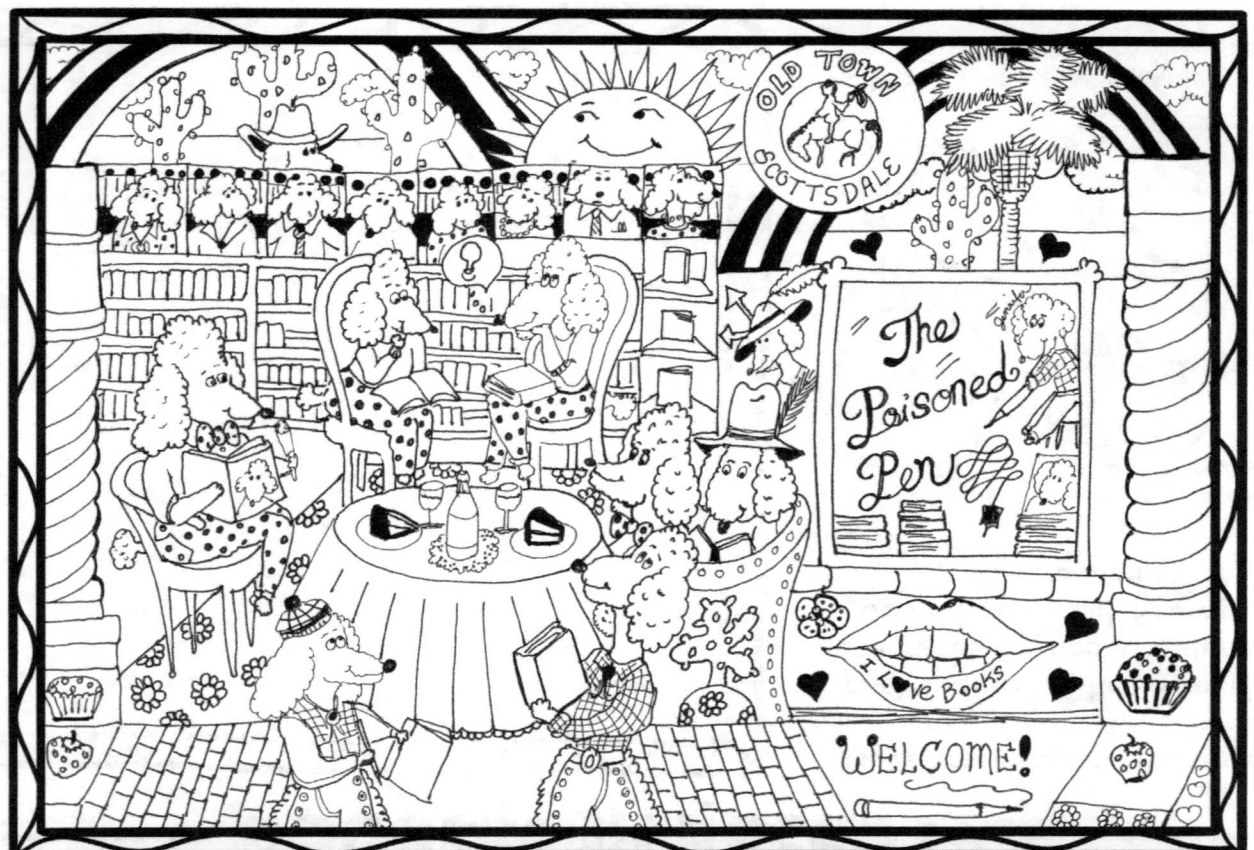

POISONED PEN POODLES PONDERING PHILOSOPHICAL POEMS

What thoughtful poems or life thoughts can you share on this page?

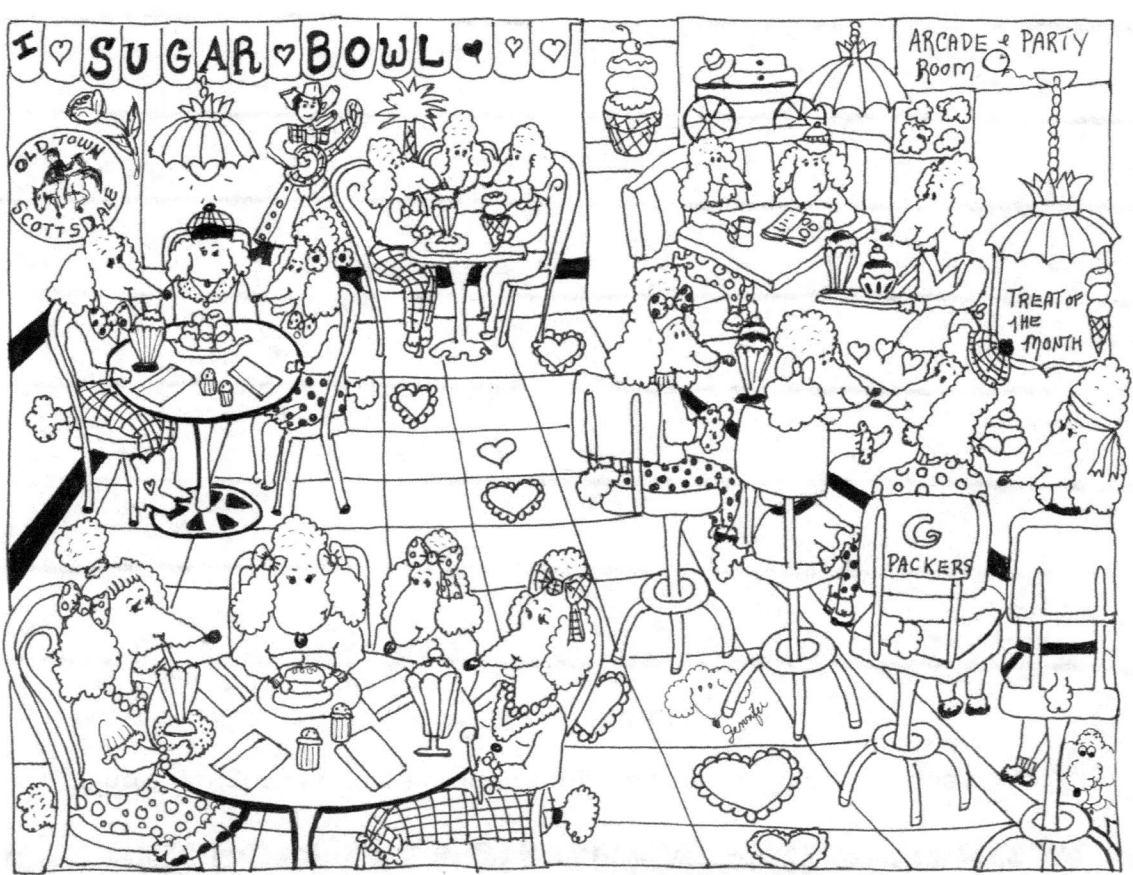

POODLES IN THE SUGAR BOWL

I bet you have a favorite ice cream flavor, or a special experience you celebrated at an ice cream shop. Tell about it.

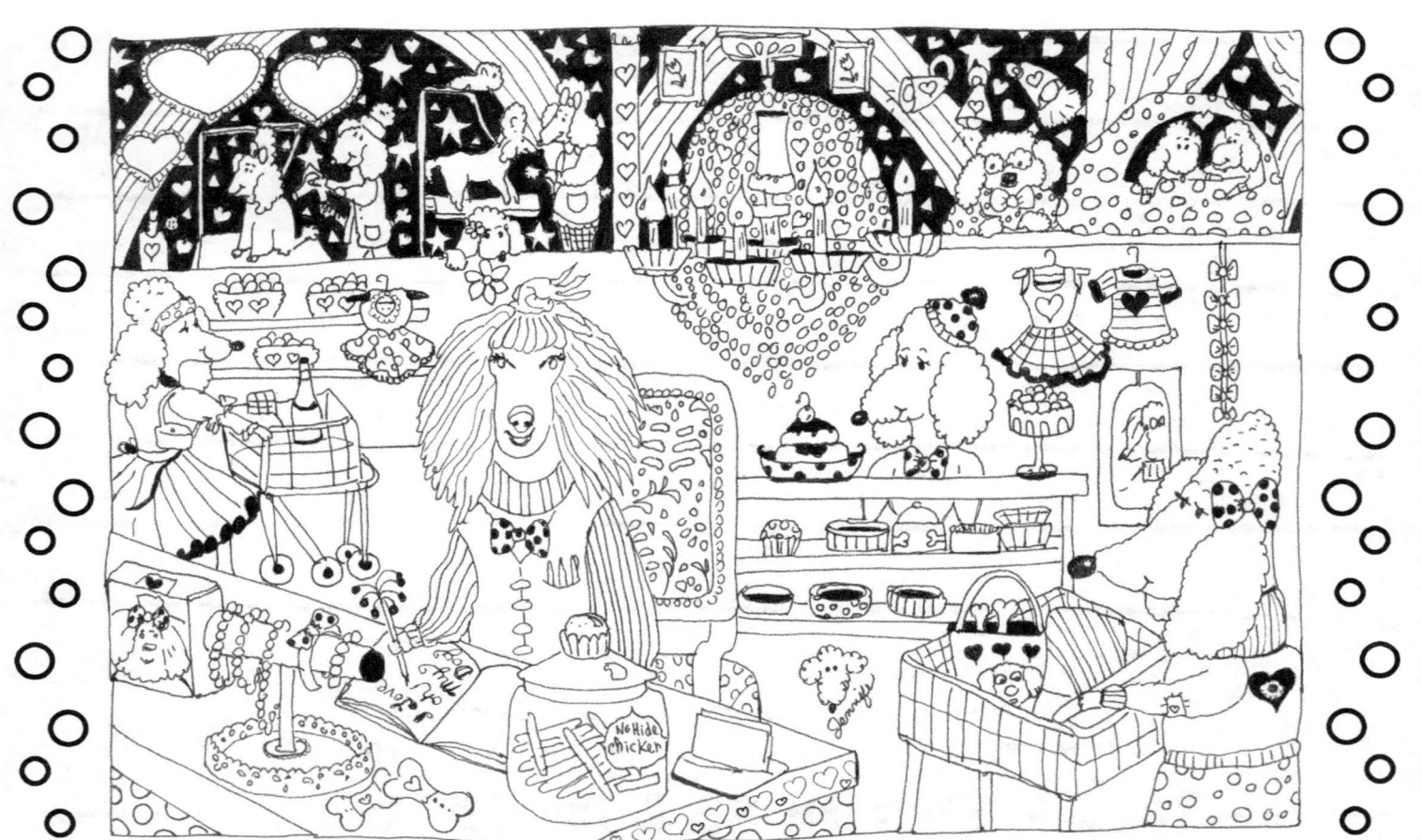

POODLES IN OH MY DOG BOUTIQUE

Friends to hang with are the best! Can you create or share a fun dog-stay story?

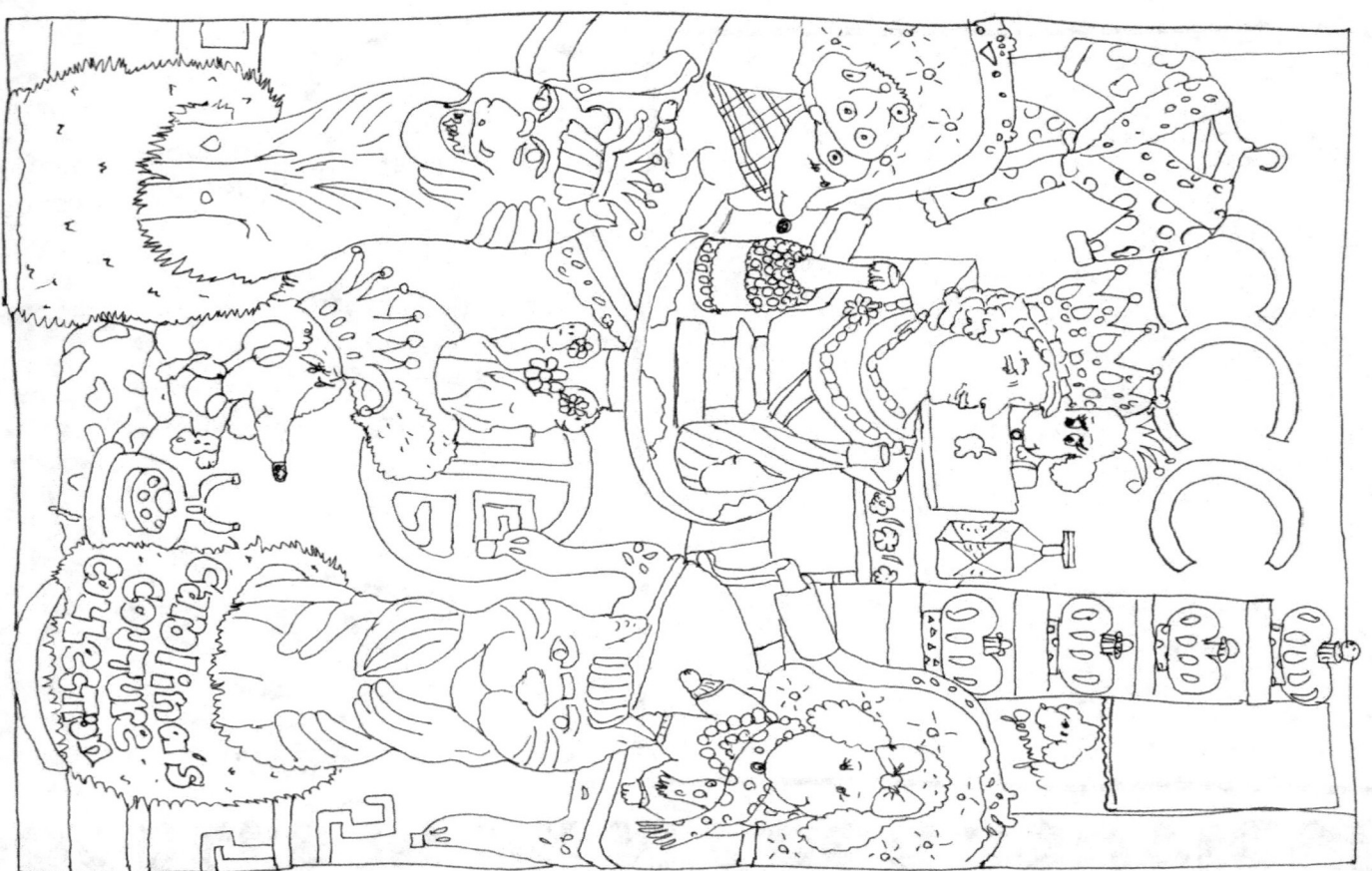

CAROLINA'S COUTURE COLLECTION

Sketch or write about your dream wardrobe with an Italian or French flair.

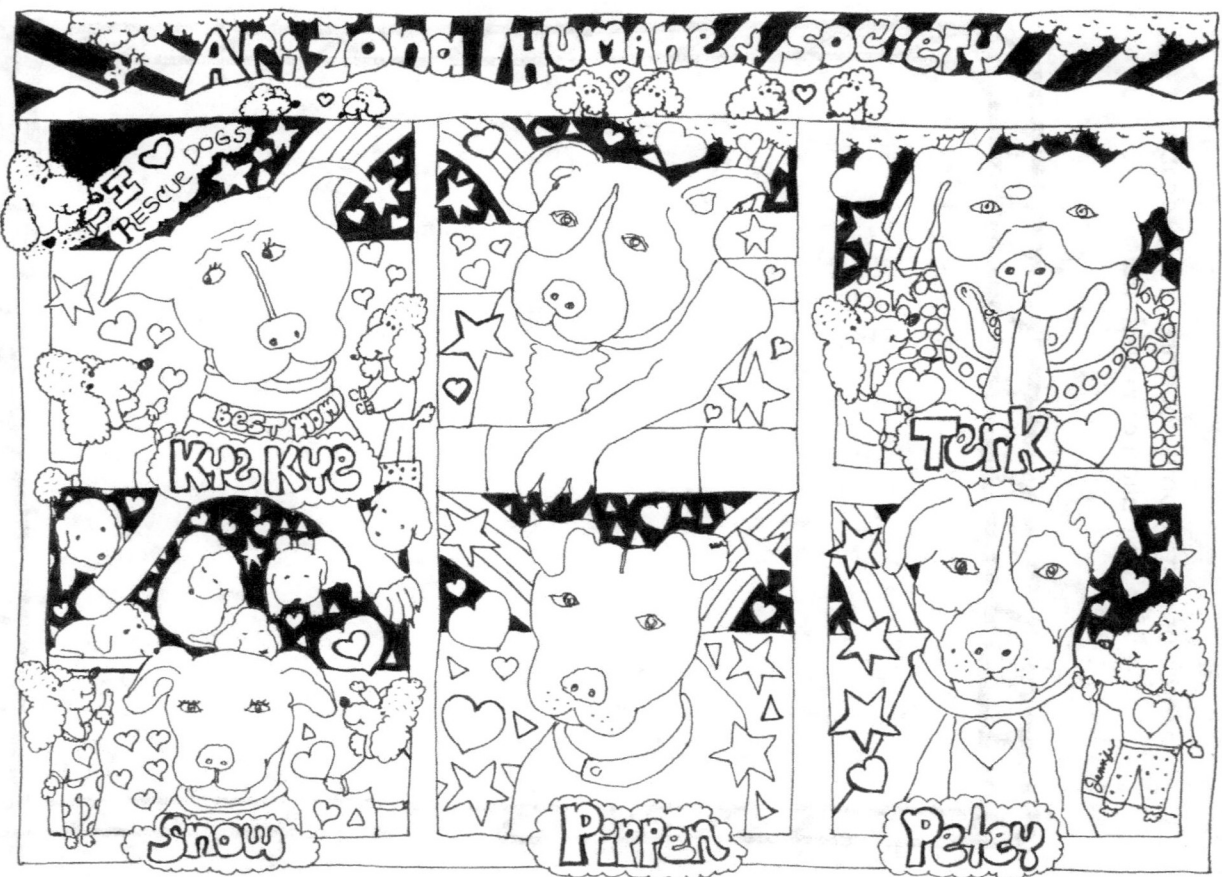

ARIZONA HUMANE SOCIETY DOGS

KYE KYE

Ten newborn puppies can be overwhelming, especially when you're trying to care for and protect them on a broken leg. That was the struggle for our Emergency Animal Medical Technicians™ found Kye Kye facing when they rescued the stray pit bull and her pack of puppies from the streets of Phoenix. Kye Kye was brought to our Second Chance Animal Trauma Hospital™ where our veterinarians tended to her injured leg, and then she and her puppies were transferred to our Mutternity Suites to allow Kye Kye to nurse and tend to her puppies in a quiet, safe place with medical supervision. After several weeks, Kye Kye and her pups were moved into a Foster Hero home to continue their care. Eventually, all 11 found forever homes!

TERK

Terk arrived at AHS very skinny and covered in ticks. He was reportedly chased down the street by a person before a Good Samaritan stepped in and brought him to us. Terk was treated in our Second Chance Animal Trauma Hospital™ and spent several months working with our Behavior team to improve his manners before finding his forever home in Chandler.

SNOW

Snow was transferred to the Arizona Humane Society from Maricopa County Animal Care and Control through our New Hope Program. This 7-month-old puppy was suffering from wounds to her neck that required surgery in our Second Chance Animal Trauma Hospital™. Snow now lives with her new family in Phoenix where she enjoys snuggling, learning new tricks, and wiggling her bottom.

PIPPEN

Pippen was spotted limping along the road by a Good Samaritan, who brought him to the Arizona Humane Society. Upon examination in our Second Chance Animal Trauma Hospital™, our veterinarians discovered that the 3-year-old Parson Russell Terrier mix was suffering from a broken left femur. Our medical team placed pins in Pippen's leg to stabilize his fracture and then he spent nearly a month recovering in our care before finding his forever home in Peoria.

PETEY

Petey was brought in from the San Carlos Indian Reservation through our Project Reachout program, which allows us to accept dogs from other animal welfare agencies throughout the state that are running out of kennel space. Petey arrived with a severe case of demodectic mange, a non-contagious skin mite that causes hair loss and itching. This handsome mix breed spent several weeks recovering in the home of a Foster Hero and now lives with his forever family in Scottsdale.

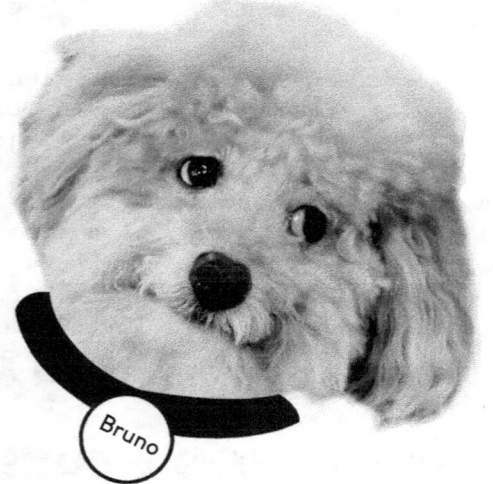

DRAW YOUR OWN POODLE!

SECTION 2:
UNITED STATES

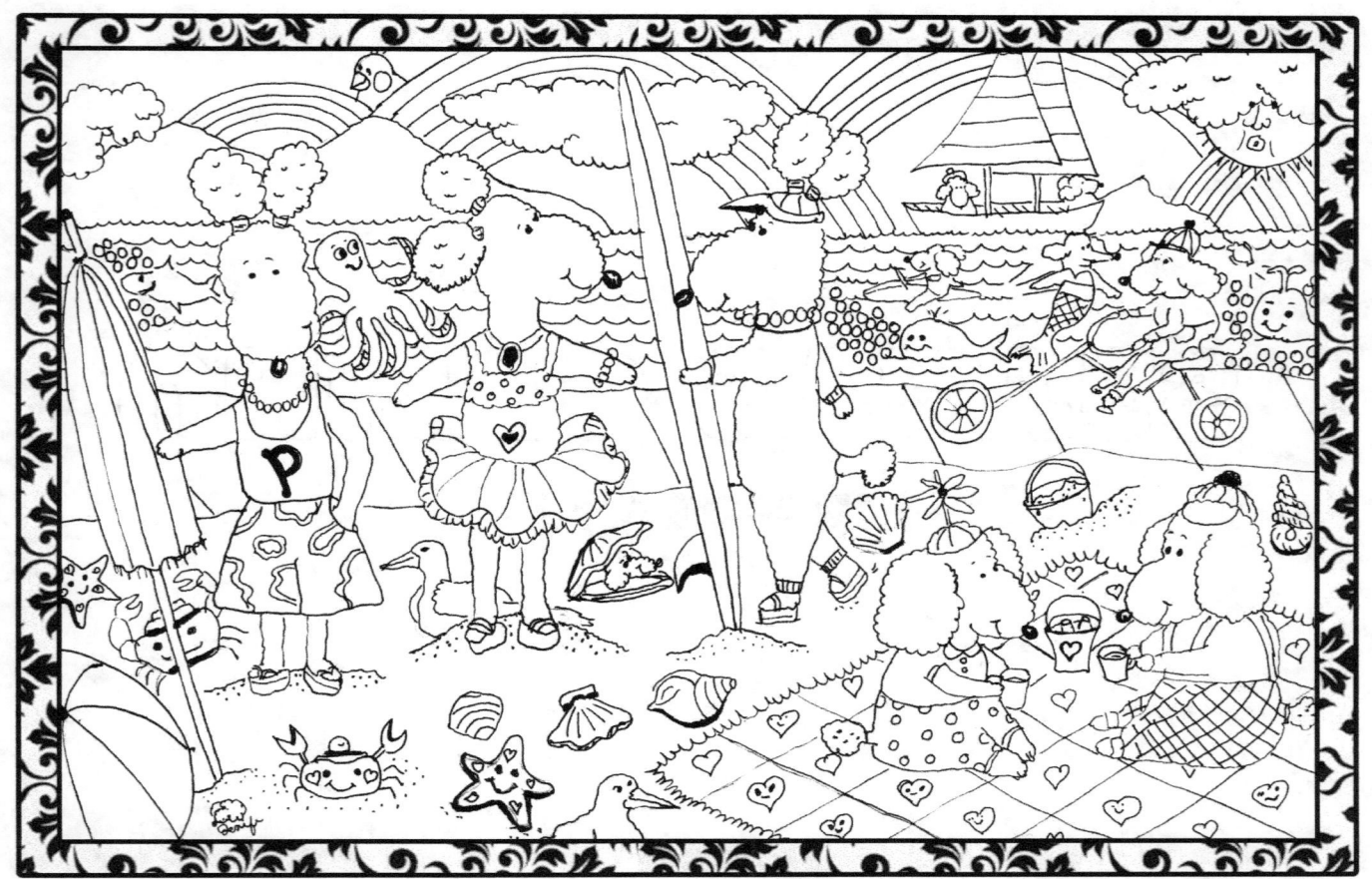

CALIFORNIA
POODLES IN THE PACIFIC PALISADES

Nothing says fun in the sun like the beaches in the Pacific Palisades! Draw your favorite California beach scene.

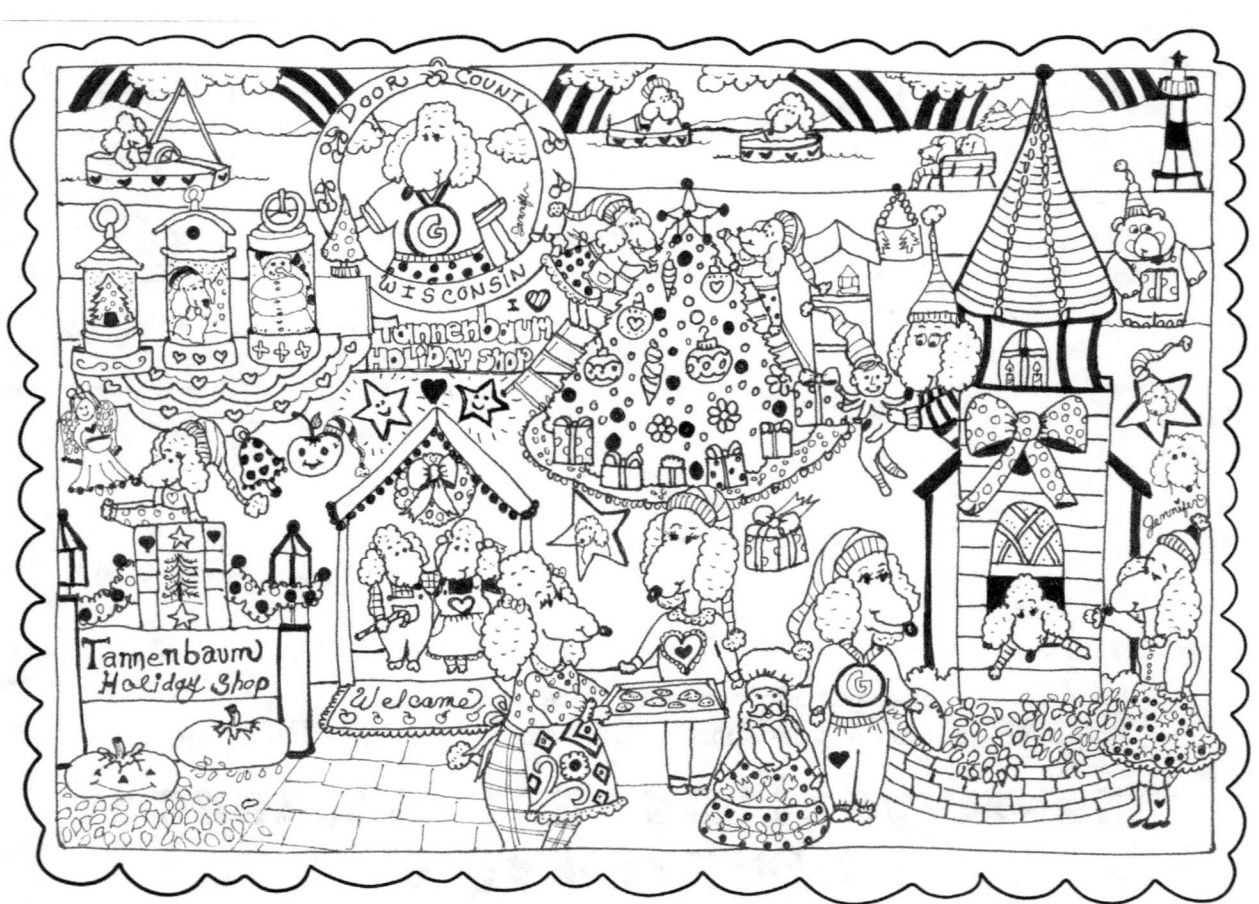

WISCONSIN
DOOR COUNTY POODLES AT TANNENBAUM

Nothing is more joyful than admiring beautiful merchandise in a holiday shop. What's your favorite holiday purchase? Why is it meaningful to you?

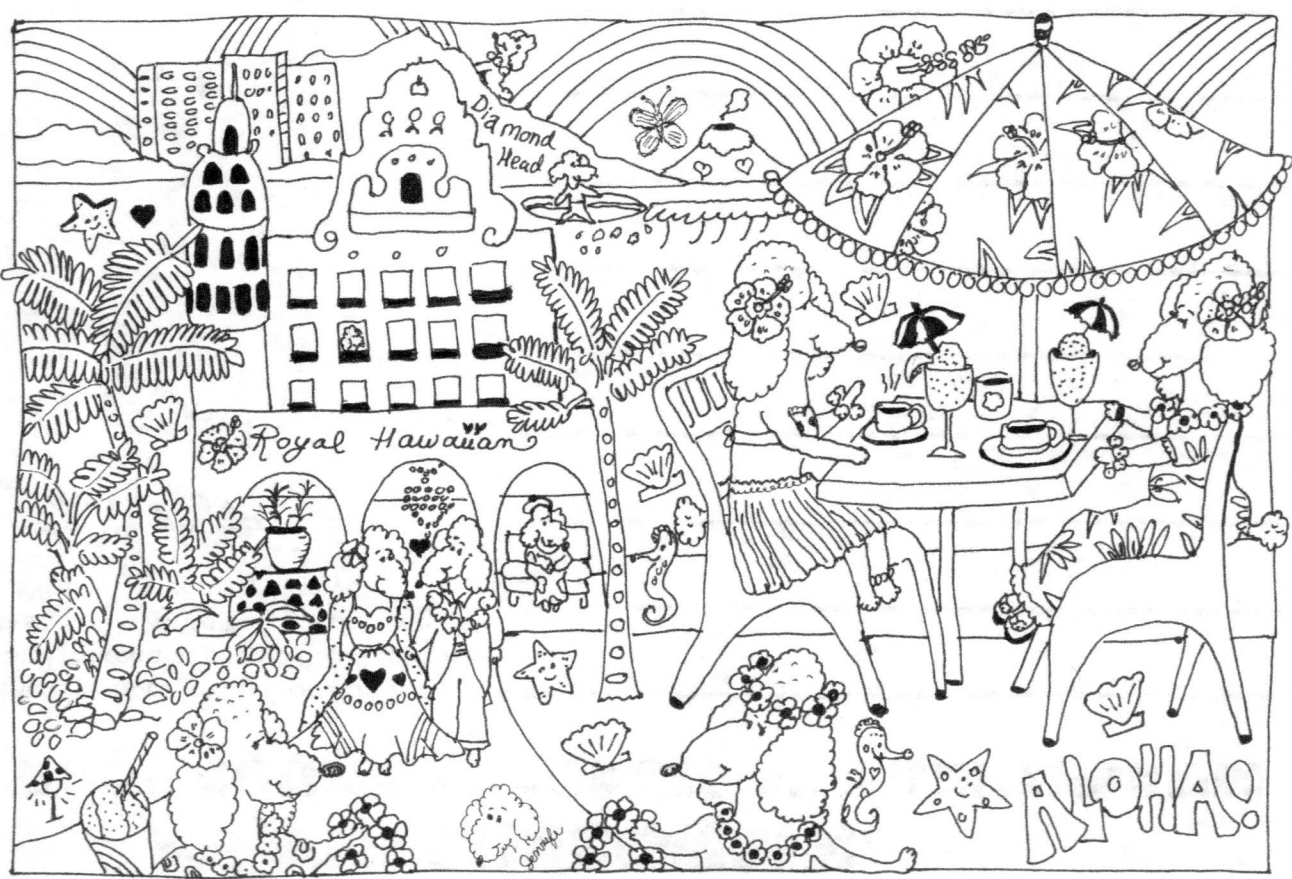

HAWAII
POODLES IN PARADISE

Pineapples, pampering, and even poodles... what's not to love about Hawaii? If you receive royal treatment in the islands, sketch out an image the experience brings to mind.

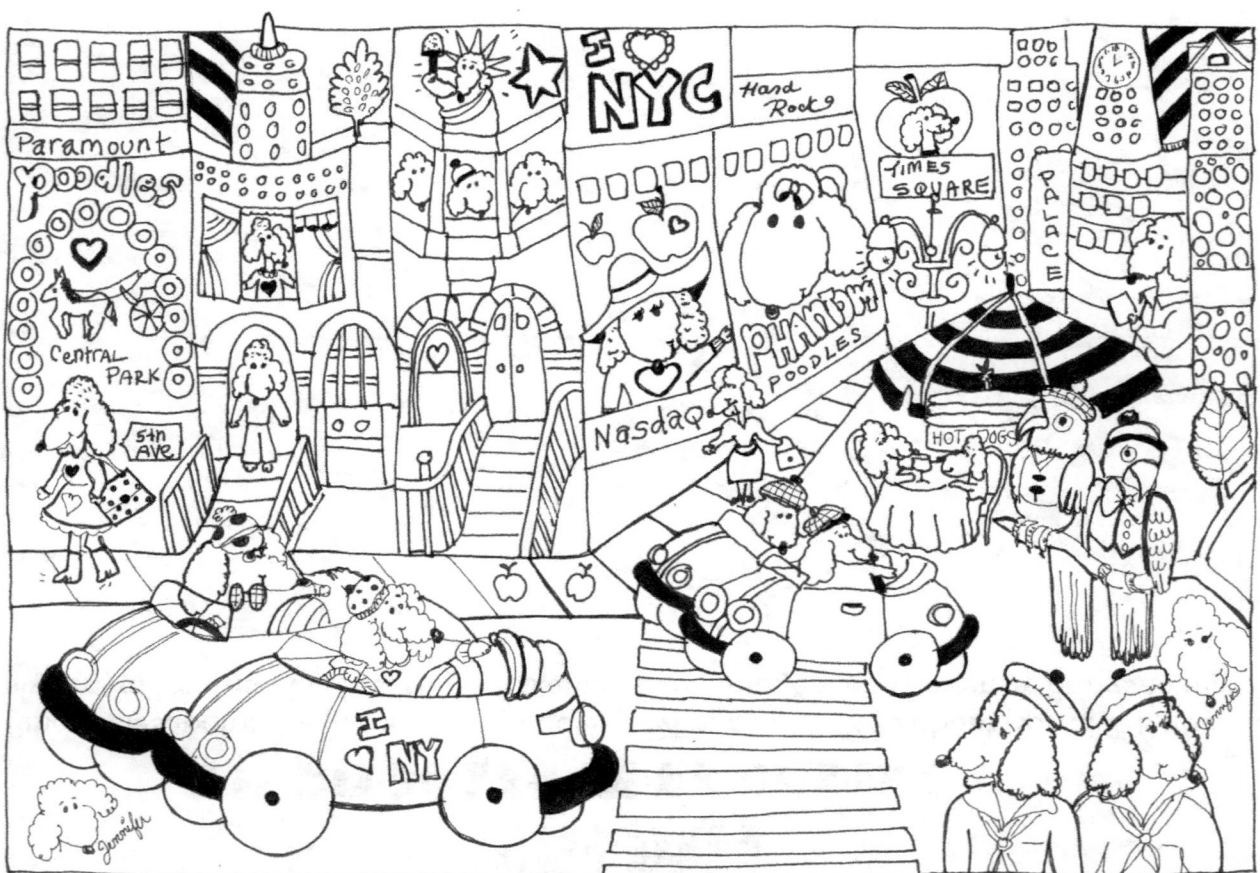

NEW YORK POODLES

New York serves up frenetic doses of food, theatre, shopping, and culture. Write a few sentences about your favorite time in the Big Apple.

SECTION 3:
GENERAL

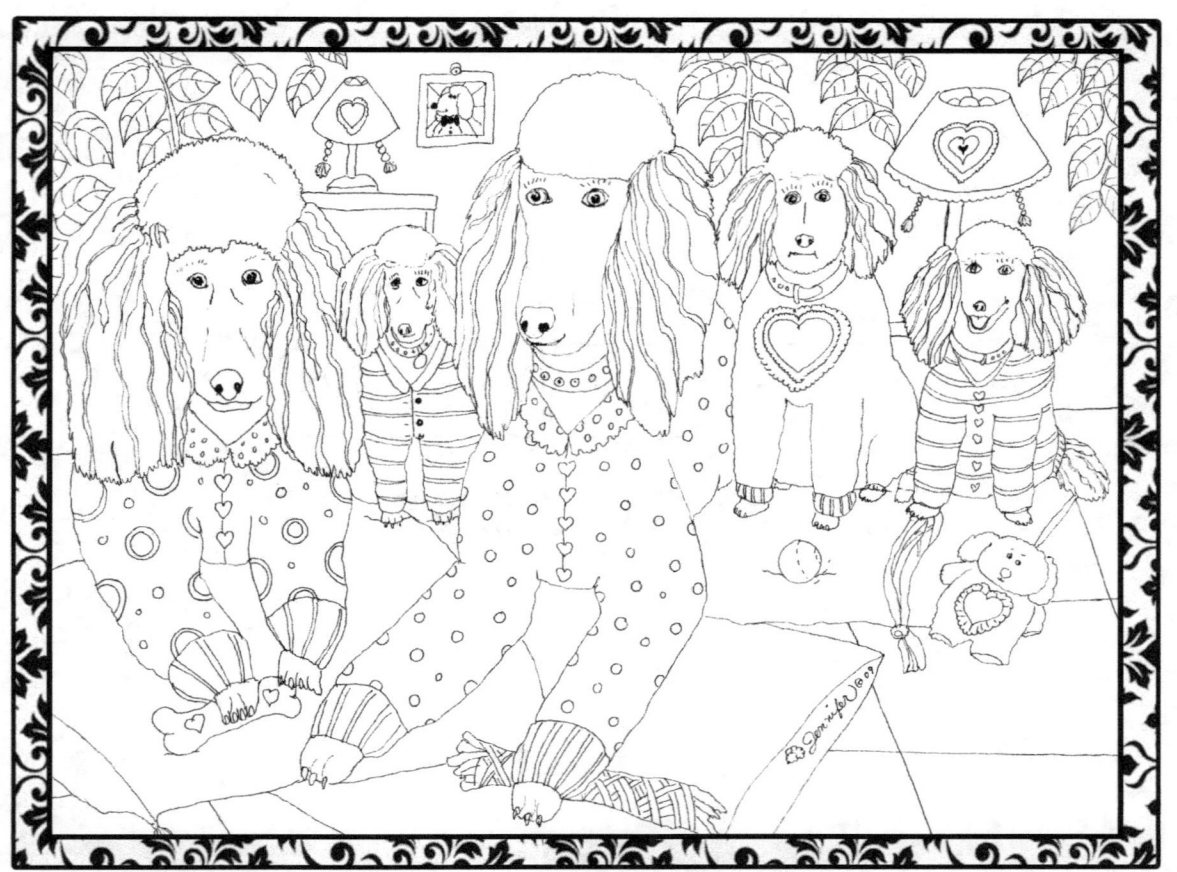

POODLES IN PJS

Any day is a good day to stay in pajamas! Have you?

Bruno

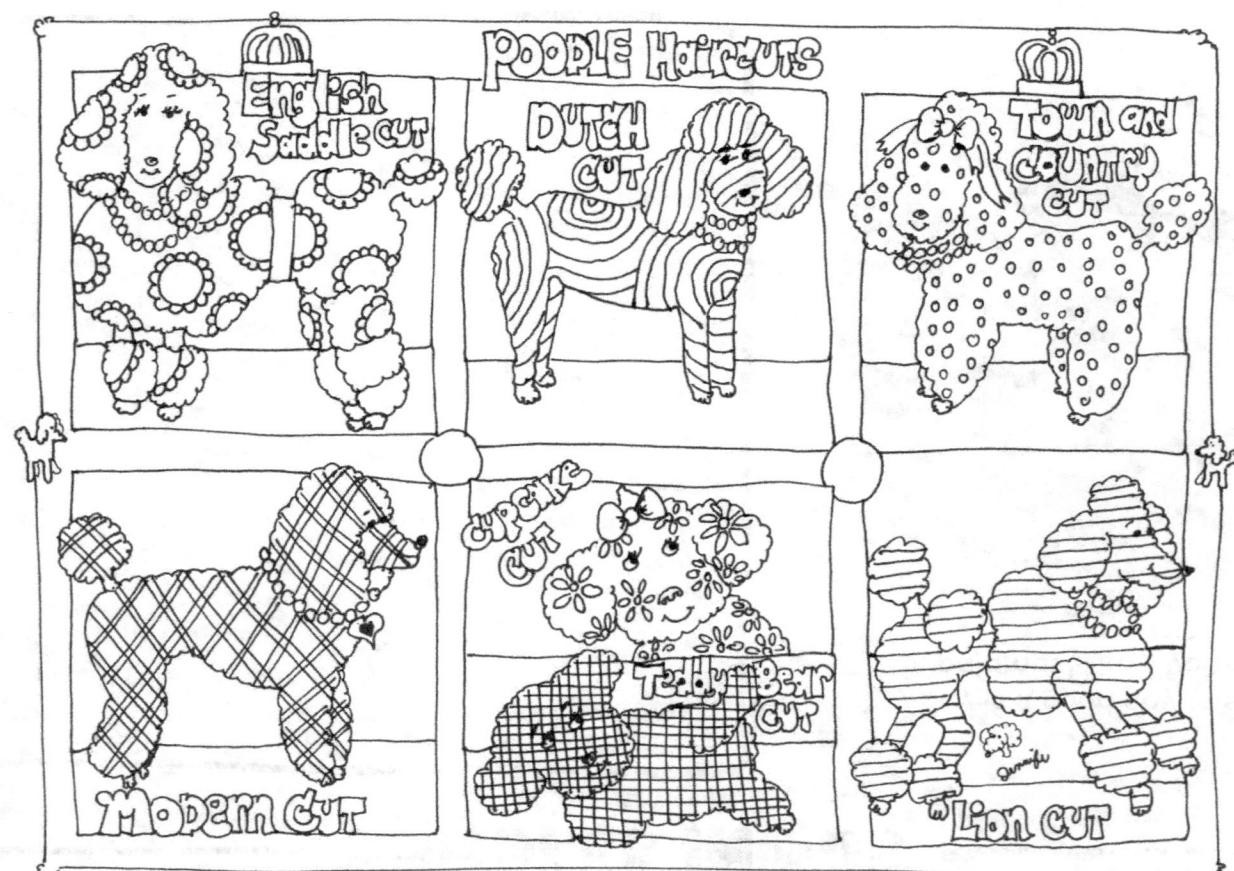

POODLE HAIRCUTS

Picture your own poodle haircut. Draw and color your own poodle with a wild 'do.

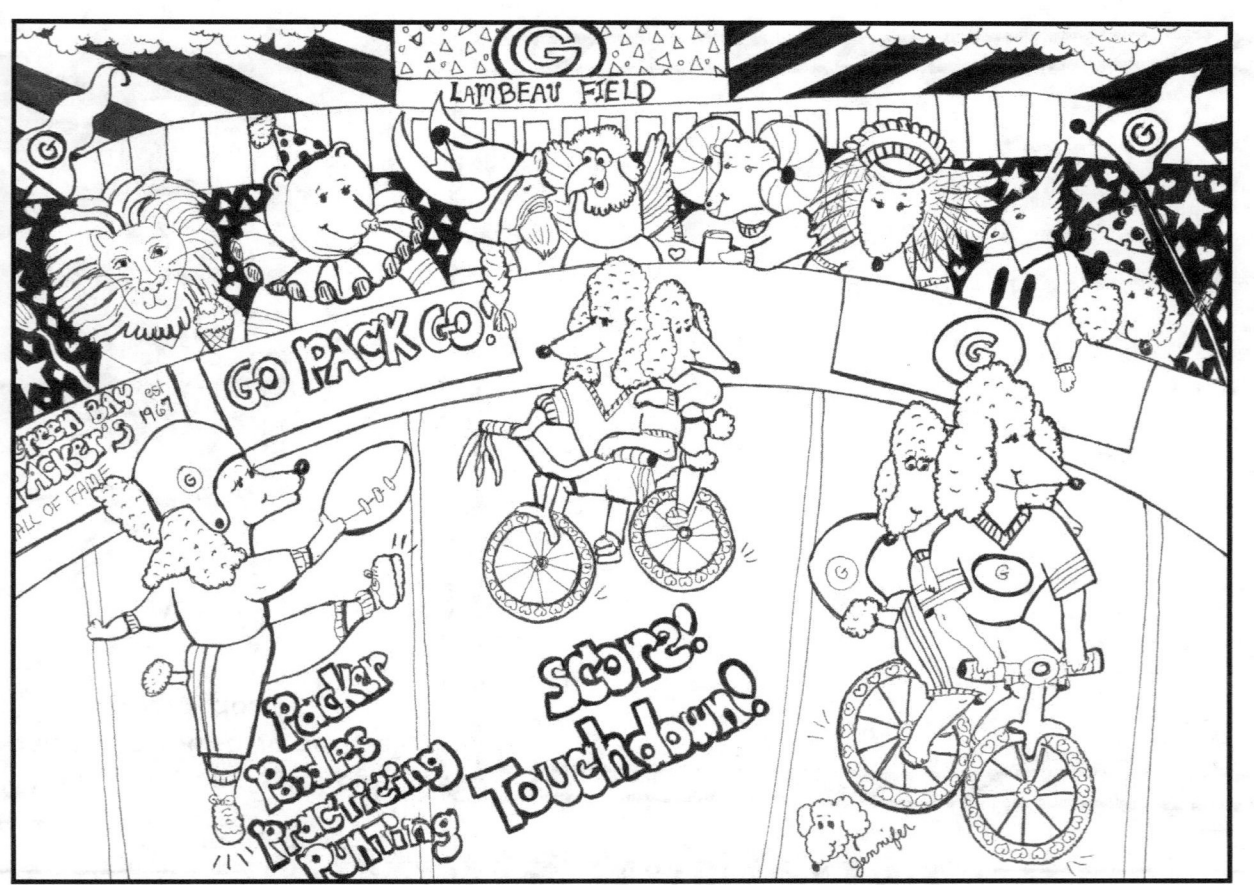

PACKER POODLES

I once saw a sign stating, "All I Need is Football and My Dog." That gives a new meaning to "Go Pack Go!" doesn't it? What slogan can you create?

SECTION 4: INTERNATIONAL

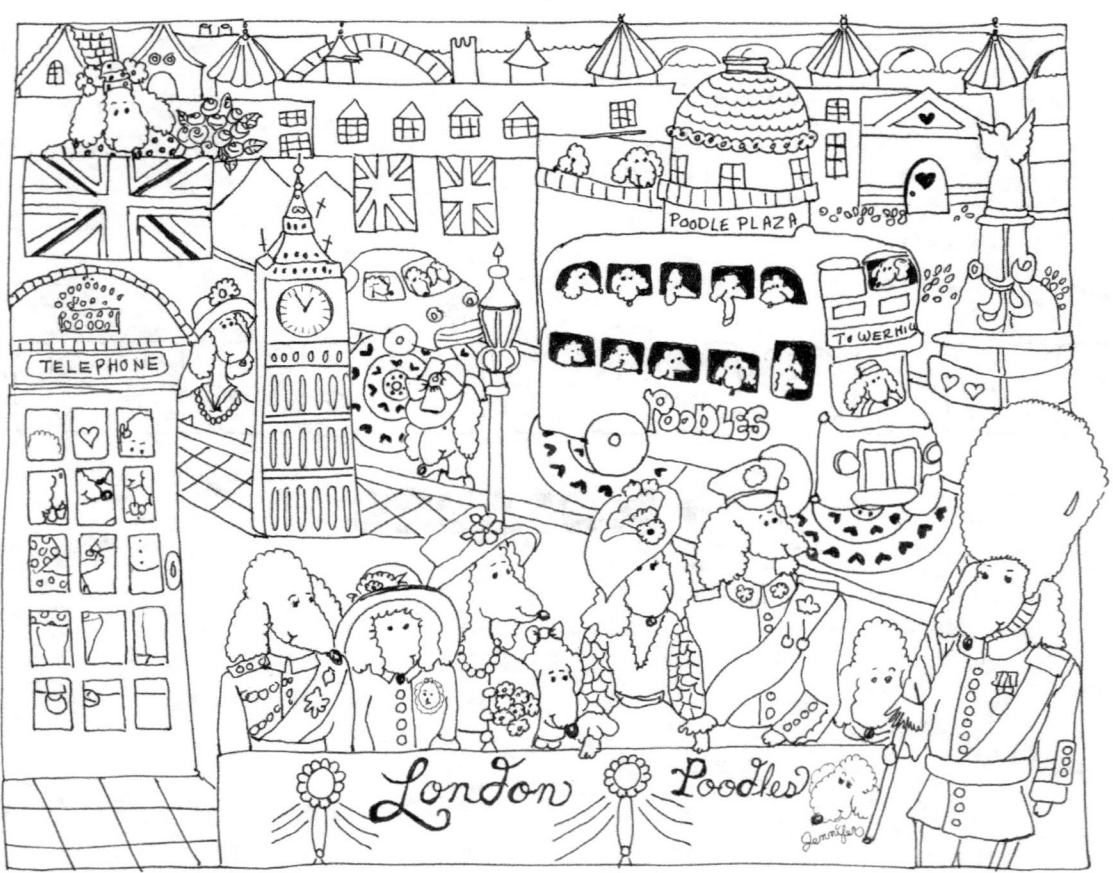

LONDON
ROYALLY LONDON POODLES

If you were visiting London right now, what would you do? Ride a double-decker bus, visit a castle, sit on the steps of St. Paul's Cathedral? Time for show or tell.

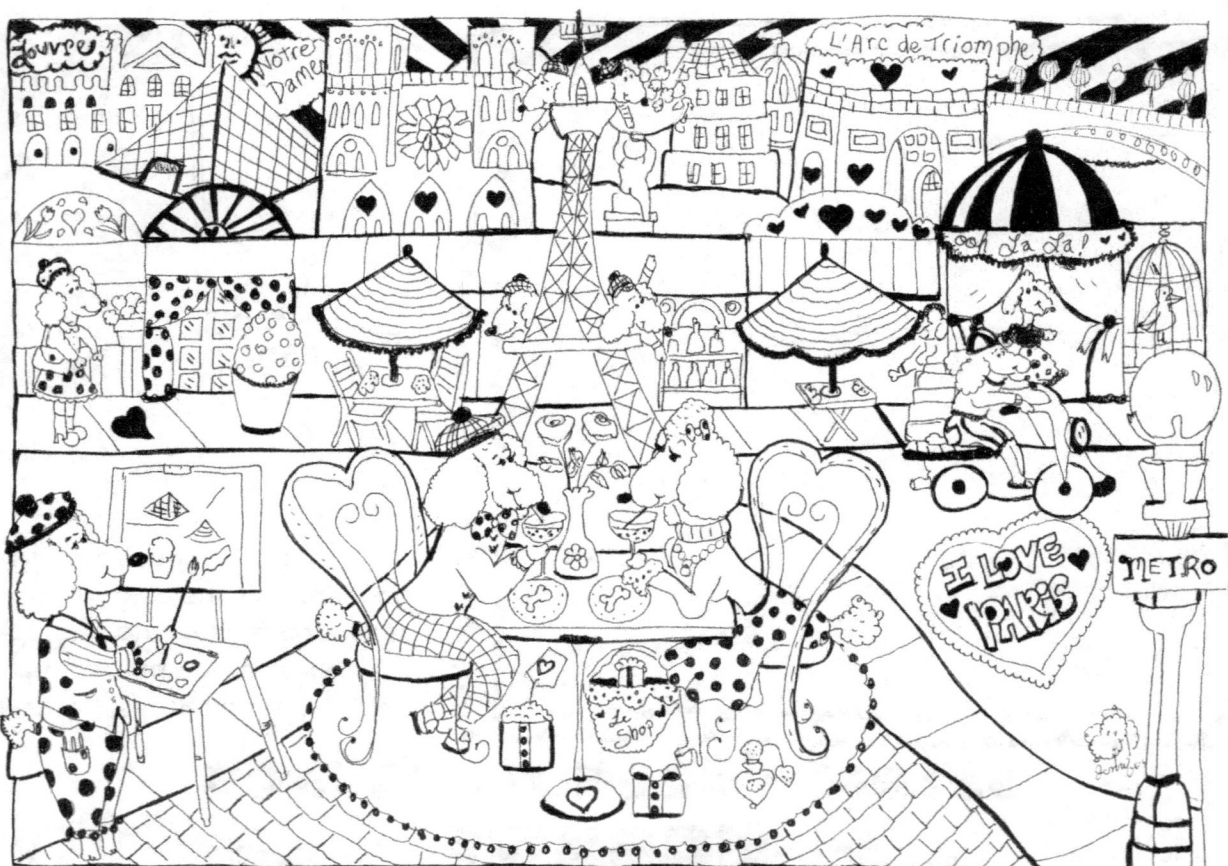

PARIS
PARIS POODLES AT TEA

Is a stop alongside the Seine River your cup of tea? Or do you fancy sightseeing at the Eiffel Tower, or shopping for the latest fashion? Tell us about your Paris dreams.

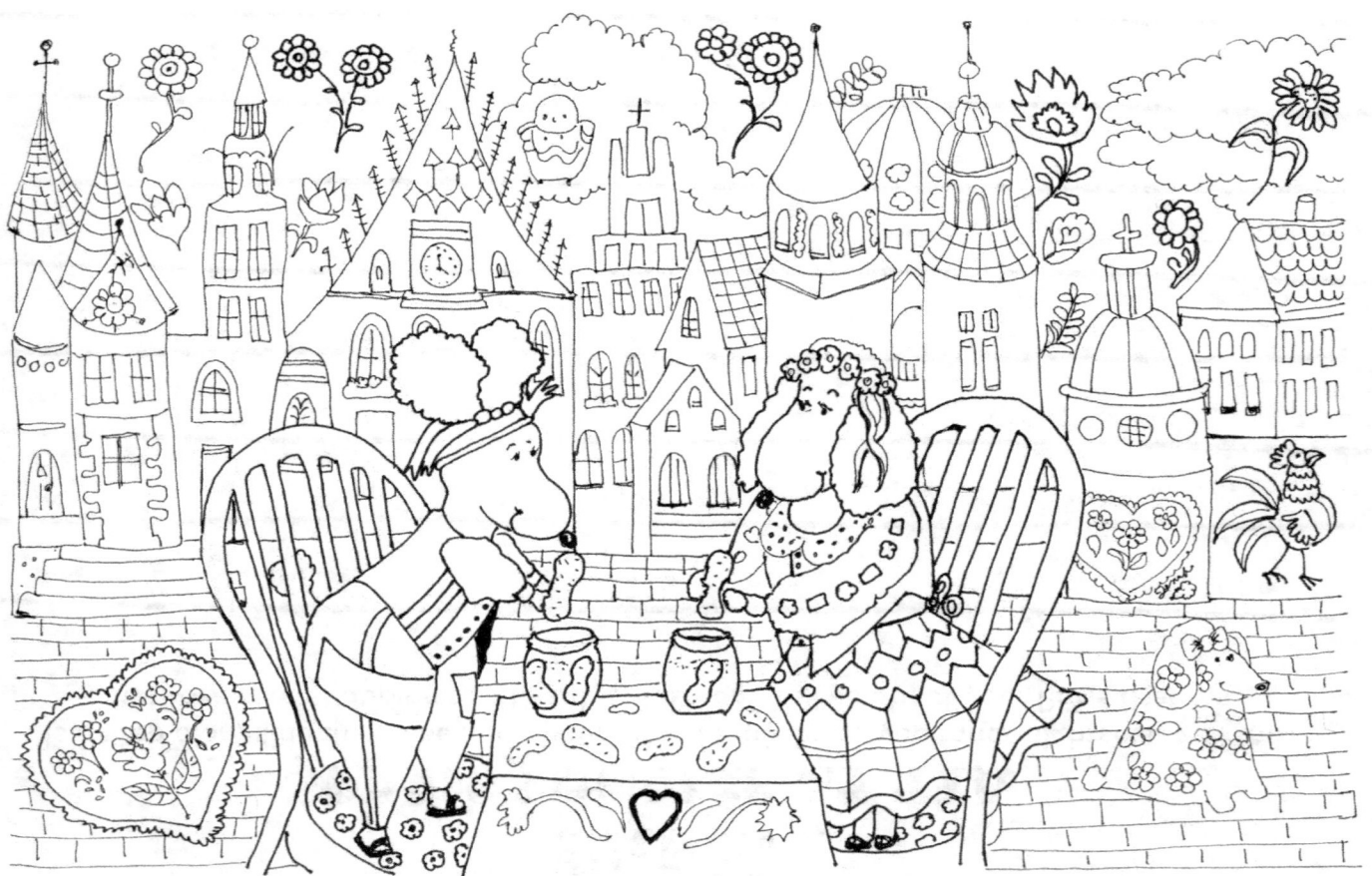

POLAND
POLISH POODLES PICKLING PICKLES

What is your favorite pickled food? The famous Polish kind? Bruno is a "pickle boy," for sure.

Bruno

SECTION 5: POODLE FUN

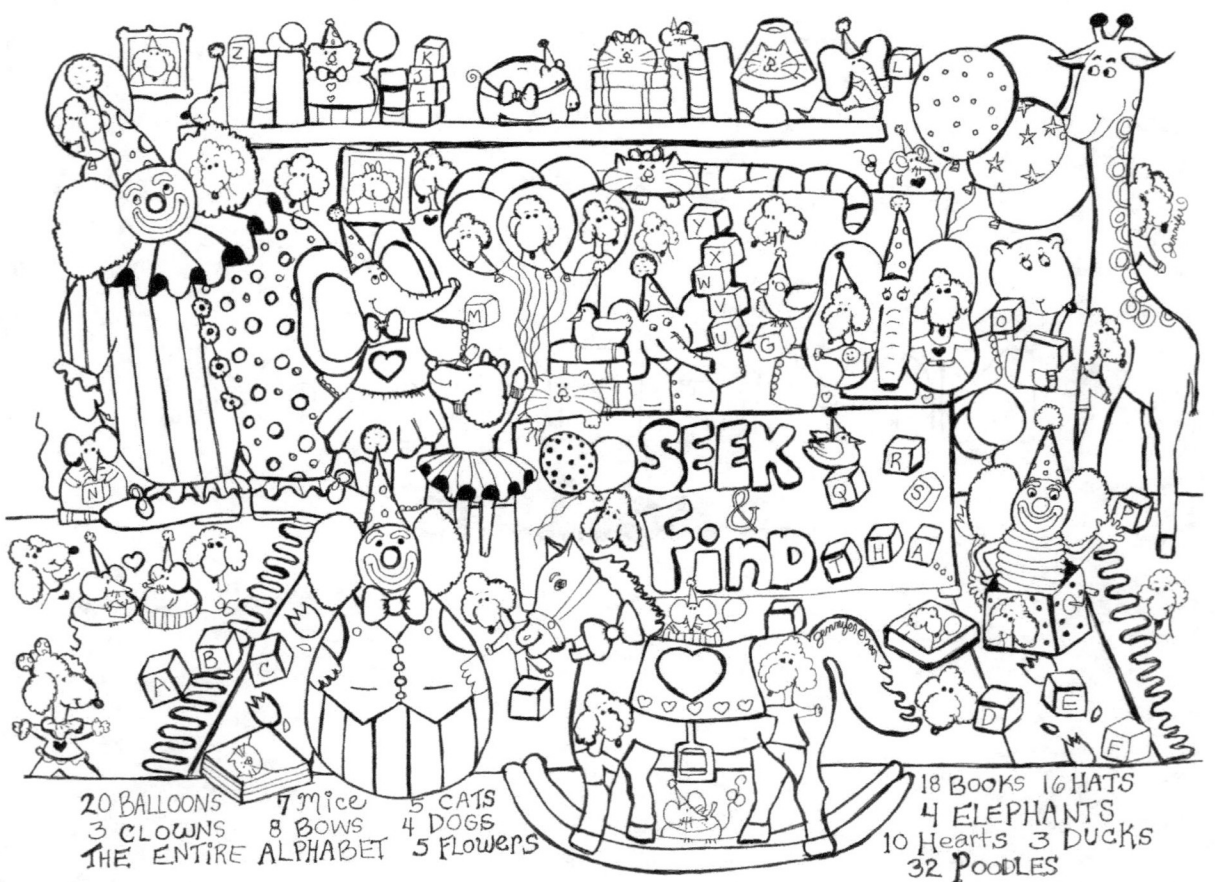

BRUNO THE POODLE'S WORD SEARCH

```
N C L C C E L O N D O N W S A
E P W A P Q S H X Q L V C G I
W G O L V G K V A I H O B E D
Y O B I Z Y P S Y I T G L T N
O D R F S M K O T T R D W G I
R Y A O S O N I S N O C S I W
K M G R Z G N D P O E A U L L
H H U N B L A E P O N C T T V
A O S I F L P R D I L E C I S
W I P A E O S V L P S A D A R
A J H R N J H O W A E I N U M
I M Y C P D R X U G G N R D Q
I J H A C A O N U R B E S A L
P O R S C H E S B I G R R H P
S L W E Y F A N O Z I R A P Y
```

Find and circle:
Accent
Arizona
Bruno
California
Carolinas
Haircuts
Hawaii
India
London
NewYork
OhMyDog
Paris
PJs
PoisonedPen
Poland
Ponchos
Poodle
Porsches
RegalRags
Scottsdale
SugarBowl
Wisconsin

DRAW YOUR OWN POODLE!

ACKNOWLEDGMENTS

This book would not have come about without Bruno, my loving poodle and author muse. I cannot thank him enough for his creative writing and art inspiration.

My sincere thanks to Book Shepherd Ann Videan and graphic designer Grace Quest, too, for helping me compile and present the content just the way I pictured it.

I want to thank my friend Rose Marie Wargo for her technical support.

Also, many thanks to the businesses that showed such interest in participating in Bruno's book:

Regal Rags • regalrags.com
Accents Boutique • thephoenician.com/resort-shops
The Poisoned Pen Bookstore • poisonedpen.com
Sugar Bowl • sugarbowlscottsdale.com
Oh My Dog Boutique Hotel & Spa • ohmydogboutique.com
Carolina's Couture Collection • carolinascouture.com
Arizona Humane Society • azhumane.org
Tannenbaum Holiday Shop • tannenbaumholidayshop.com
Royal Hawaiian Hotel • royal-hawaiian.com

In conclusion, let me express my true appreciation for family and friends who supported and encouraged me behind the scenes in the creation of this book.

If you liked this book, please consider posting a review about it on J.J. Jordan's Amazon book page!